This is a **FLAME TREE NOTEBOOK**
Designed, published and © copyright 2014 Flame Tree Publishing Ltd
Based on an illustration © Blackspring/Shutterstock.com

Blue Skulls • ISBN 978-1-78361-379-3

FLAME TREE PUBLISHING LIMITED
Crabtree Hall, Crabtree Lane, London SW6 6TY, United Kingdom
www.flametreepublishing.com